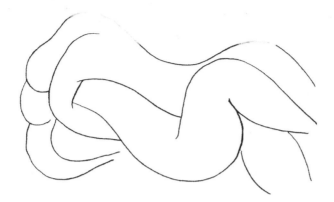

# INTIMATE MATISSE

■ national gallery of **australia**

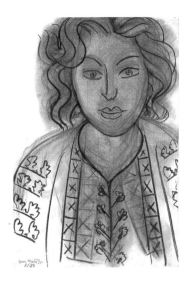

HENRI MATISSE (1869–1954) considered his drawing to be a very intimate means of expression. — the 'purest' and 'most direct'.[1] His method of execution — whether charcoal, pencil, crayon, etcher's burin, lithographic tusche or paper cut — varied according to the subject and the artist's personal circumstance. Frequently his composition was of the female form — the figure or head of a favourite model of the time.

# FEELINGS OF YOUTHFULNESS

MATISSE found much of his inspiration in poetry. Like his art, the poetry or poetic prose he loved was intimate, sensuous and personal. In his later years the artist developed the practice of reading poetry early each day before lifting a paint brush, pencil or burin. He believed that poetry kept him young at heart. In correspondence in 1943 to his friend, the Surrealist writer Louis Aragon, Matisse, then in his mid-70s, remarked that taking in the lines of the great medievalist poet, Charles d'Orléans (1391–1465), was like inhaling oxygen: 'every morning of every day, just as when you leap out of bed you fill your lungs with fresh air'.[2] The tales of courtly love of the sixteenth-century poet, Pierre de Ronsard (1524–1585), were another important source of inspiration, like a sensual elixir of youth. In a letter to a confidant, André Rouveyre, Matisse wrote that, because of such inspiration, 'my feelings of freshness, of beauty, of youthfulness remain the same as they were thirty years ago'.[3] Little wonder that he delighted in creating imagery which related to his favourite texts.

From his early sixties to the time of his death, Matisse's desire was to be a painter–illustrator of significance. In response to his literary loves he created series of drawings in the great French tradition of the artist's book (*livre de peintre*) — where original prints by talented artists and carefully selected texts are married harmoniously in beautiful books. With special papers and coloured inks, these books display great attention to detail and overall page design. Published in limited numbered editions, there is often a *de-luxe* version including extra suites of the artist's work.

## JUGGLING

MATISSE'S FIRST VENTURE in the field was published in 1932 — his illustrations accompanying a selection of the work of the French Symbolist poet, Stéphane Mallarmé (1842–1898). This was in response

to an approach by the young Swiss publisher, Albert Skira, who was anxious to secure Matisse for a *livre de peintre*. Matisse's agreement may have been influenced by the fact that Skira already had Pablo Picasso's agreement to do the same — although actually getting Picasso to produce his illustrations for the resulting masterpiece, Ovid's *Métamorphoses*, proved to be a lengthy and trying exercise for the publisher.

Initially the plan was that Matisse, like Picasso, would select a classical theme. Matisse first chose *Amor et Psyché* by Jean de La Fontaine; but he subsequently decided on Mallarmé, perhaps because of the poet's influence on his mentor and teacher, Gustave Moreau. Matisse later recalled that Moreau was 'a charming master', who gave 'intelligent encouragement' and recognised the young artist's talent when he was a student in Paris.[4]

Avoiding Mallarmé's more rhetorical, highly dramatic writing, Matisse mostly selected subjects which related to the poet's evocative themes. These he distinguished with a series of exquisite etchings in which he sought to create 'a very fine line, without hatching, so that the printed page is left almost as white …'[5] Lovers entwined, delicate nude female forms, flora and fauna, as well as portraits of Charles Baudelaire and Edgar Allan Poe, were laid out in imaginative juxtaposition with tales of passion. The pairing of Mallarmé's text with his own compositions, Matisse likened to the 'juggling' of black and white balls — where movement, contrast and harmony all needed to be balanced. Compared to Picasso's classically-inspired subject matter, Matisse's choice of writer and his designs for Skira were far more radical.

## A MEDIEVAL MANUSCRIPT

MANY YEARS LATER Matisse similarly concentrated on the more sensual themes of Pierre de Ronsard, the poet who so invigorated him. His selection of thirty-five poems for a *Florilège des amours* [*Anthology of Love*],

was published by Albert Skira in 1948, although planned as early as 1941. Once again the artist 'juggled' poetry and imagery, although there is now a greater fusion of the elements as they overlap and entwine on the page. The apparent effortlessness of the delicately drawn lithographs of faces, bodies, lovers, fruit and flowers reveals the artist's extraordinary confidence in his material.

The inspiration of the medieval illuminated manuscript was increasingly apparent in Matisse's work. Such manuscripts, with their careful blending of written word and imagery, were intended to be beautiful objects in themselves. The illustrations, rich in colour and pattern, often executed with a sinuous line, accompanied handwritten scripts with elegant initial letters and margin designs of human forms, animals, plants and grotesqueries. Matisse was to become a formidable twentieth-century exponent of this art.

## A LACK OF GRACE

IF MATISSE was at his most comfortable with the romantic and erotic in literature, he was less so with the contemporary 'stream of consciousness' style of James Joyce, and his attempt to draw imagery for Joyce's *Ulysses* was probably his least successful undertaking. Matisse had not read the book, as he was sure he would not comprehend it and, as he felt he had no sympathy with the Joyce's style, the artist turned instead to the Homeric epic that had inspired the writer.

Undecided until the last moment about the technique he would use, Matisse chose a smudgy looking method of soft-ground etching, as if to present his compositions through a blurred lens. The result is surprisingly awkward — the exception is the drypoint of Nausicaa and two young handmaidens, referred to in Homer's lines (Book VI). They are pictured as *The Three Graces* standing before the ancient Greek hero,

like the 'immortal goddesses for stature and beauty'.[6] Perhaps *Ulysses* is most interesting because of the inclusion of reproductions of Matisse's preparatory drawings, which reveal his struggle to produce the simple forms and delicate lines we associate with this French master draughtsman — the *arabesque* had deserted him.

Matisse was unhappy about the final form of the publication. He was disappointed with the quality of printing and that he was not adequately consulted about the typography or layout of the book.

## BEAUTY AND THE BEAST

IN 1943 MATISSE agreed to illustrate another classical theme, *Pasiphaé: Chant de Minos* — Henry de Montherlant's (1896–1972) composite poem and drama loosely drawn from the ancient myth, where Pasiphaë, the wife of King Minos of Crete, falls in love with a white bull. In the classical tale, Pasiphaë disguises herself, changing from woman to animal, so that the beast will desire her. In Montherlant's *Pasiphaé*, the emphasis is placed more on passion, romance and light, rather than the revenge, bestiality and darkness of the ancient Greek and Latin sources. When Matisse finally agreed to illustrate the work, after several years of persuasion by the author, he described Montherlant's writing to be work of a 'very rare literary quality'.[7]

For *Pasiphaé*, Matisse chose the relatively simple technique of linocutting, which he employed with startling success. His forms, outlined in shimmering white from the gouged line set on a black inked surface, reiterate Montherlant's theme of light in darkness. Elsewhere in page layouts he adds a Chinese red to the ornamental initials and borders 'the colour of power and of happiness'. As well as episodes relating directly to the lines of poetry, Matisse prepared for the *de-luxe* edition a sequence depicting the metamorphosis of the hapless Pasiphaë, transformed by her passion from beauty to beast.

# A LAST LOVE LETTER

ANOTHER METAMORPHOSIS takes place in *Lettres portugaises* [*Portuguese Letters*]. This literary conceit consists of letters, written under the *nom de plume* Marianna Alfcaforado, but probably by the hand of the 'translator', the seventeenth-century nobleman, Gabriel-Joseph Lavergne. The young Marianna had been abandoned at a convent by the French officer she adored: their romance, her passion and final despair are described in a sequence of letters. As the realisation grows that she has been deserted, Marianna pens the words of yearning: *I am writing to you for the last time, and hope to make you understand from the difference in my expression and the style of this letter, that even to the last you possess me ... even though I flatter myself that I no longer care for you ...* With this realisation, we see the beauty drain from her face and her eyes glaze in a series of simple portraits by Matisse.

It was Matisse's habit to choose one youthful model after another as inspiration for his art and to suit his romantic themes. For *Lettres portugaises* his model was a fourteen-year-old girl of Russian extraction, Doucia R, who lived in Nice. Matisse emphasised the romantic and erotic nature of this sorrowful love story by including symbolically in his designs ripe pomegranates and carpets of flowers, based on drawings from his garden in Vence, amongst the poignant correspondence of Marianna.

# PERFECTING DRAWING

DURING 1941–42, following serious illness and surgery, Matisse embarked on a concentrated program of drawing. For example, he produced 158 completed compositions which he arranged in thematic groups known as *Themes and Variations*. Matisse usually began these drawings with a carefully studied charcoal drawing, followed by a sequence in fine lines, such as pencil, which he produced in an almost trance-like state

as he circled the model — aiming for the essence of the character and a refinement of presentation. In a letter to his daughter, Marguerite Duthuit, he wrote: 'for a year I have made a very considerable effort, one of the most important in my life. I have perfected my drawing and made surprising progress'. The qualities Matisse was searching for were 'ease and sensibility, liberally expressed with a great variety of sensations and a minimum of means'.[8]

A later sequence of *Themes and Variations,* executed in 1946, featuring a favourite model of that time, Dutch-born Annelies Nelck, reveals the power of refined drawing. Matisse chose Annelies for some of his illustrations for Charles Baudelaire's *Fleurs du mal* — these he began in Vence in 1944 for the book published in Paris in 1947. He focuses on the woman's face to express the power of the nineteenth-century poet's words.

## COURTLY LOVE

THE WRITINGS of the fifteenth-century medieval romanticist, Charles d'Orléans, were much admired by Matisse and he chose to design an anthology of these tales of courtly love and youthful passion in the manner of a medieval manuscript, with his drawing and the poetry designed as a unified whole on a page. The texts were executed in Matisse's own handwriting, with marginal designs of *fleurs de lys,* other flowers, heads and animals. There is not straight line to be found — the book has an almost sculptural appearance, becoming an art object in its own right.

## A FLOWER BOOK

OF ALL OF MATISSE'S ILLUSTRATED BOOKS, *Jazz* is the most spectacular and most radical version of the modern day illuminated manuscript — the quintessential example of a 'flower book', as the publisher, Tériade, described it. Instead of a 'painter's book', *Jazz* had become a 'painter's

illuminated manuscript', extending the notion of drawing by balancing each illustration with a page of text handwritten by the artist. Matisse noted in a self-effacing way that his own thoughts which appeared in *Jazz* were 'as asters add to the composition of a bouquet of more important flowers'.[9]

In brilliant colours, swirling lines and *arabesques*, Matisse created a series of jewel-like shapes, both positive and negative, which range from the circus to female forms amongst the sea and coral. He made his images from coloured stencils based on paper cut-outs — a technique of drawing in colour that he developed while bedridden and able to use only scissors and paper to create his art. These works then formed the basis of stencilled compositions, with Matisse scrupulous in his selection of inks.

## A WAITING PARADISE

IN THE LAST YEARS OF HIS LIFE, and possibly in anticipation of his death, Matisse decided to pay homage to his friend, the late poet John-Antoine Nau, by celebrating their mutual fascination for Martinique — in the words of the poet, 'a waiting paradise'.[10] The Caribbean, just like Tahiti, inspired Matisse's imagination. For him it was a place of fantasy; in reality he took little interest in the local customs. For the intended illustrated book, it was Matisse's wish to evoke his paradise world, and so he prepared a series of faces of the beautiful women of the island, wonderfully simple and sensuous in appearance. Having completed his maquette for *Poésies antillaises* [*Poetry of the Antilles*] between the years 1950–53 — which included individual compositions, initial letters and small motifs — Matisse died before its production could take place. The book was published posthumously many years later, in 1972, by the French lithographer Fernand Mourlot.

The refined understatement and beauty of Matisse's compositions for his homage to a friend derived from years of experience. They reveal the artist

to be a master draughtsman who was able to achieve his stated desire to 'reconceive in simplicity'[11] — words that aptly describe a lifetime's approach to the art of drawing.

Jane Kinsman

1 Henri Matisse, quoted in John Elderfield, *The Drawings of Henry Matisse*, London: Thames and Hudson, in association with the Arts Council of Great Britain and the Museum of Modern Art, New York, 1984, p.121; Caroline Turner and Roger Benjamin (eds), *Matisse*, Brisbane/Sydney: Queensland Art Gallery and Art Exhibitions Australia, 1995.

2 Matisse, in a letter to Louis Aragon, 20 January 1943, quoted in the introduction by Jean Guichard-Meili to Claude Duthuit, *Henri Matisse: Catalogue raisonné des ouvrages illustrés*, Paris: Claude Duthuit, 1988, translated by Timothy Bent, p.412.

3 Matisse, in a letter to André Rouveyre, quoted in *ibid.*

4 Matisse, quoted in Raymond Escholier, *Matisse from the Life*, London: Faber and Faber, 1960. translated by Geraldine and H. M. Colvile, p.27. This was in stark contrast to the reaction of the academicians. Matisse thought them 'muddleheaded professors' who 'corrected' his work. They included William Bougereau and Jean-Léon Gérôme who were both hostile to Matisse's work when he was a young man. See Henri Matisse, 'Divagations', *Verve*, 1(1), 1937, p.84. For further information on Mallarmé see Yves Peyré, *Mallarmé, un destin d'ecriture*, Paris: Musée d'Orsay, 1998.

5 Matisse, 'Comment j'ai fait mes livres', in *Anthologie du livre illustré par les peintres et sculpteurs de l'école de Paris*, Geneva, 1946, translated in Jack Flam, *Matisse on Art*, London: Phaidon Press, 2nd edn 1978, repr. 1984, p.107.

6 Book VI, 16, *The Odyssey of Homer*, translated and with an introduction by Richard Lattimore, New York: Harper Torchbook, 1968, p.102.

7 Matisse, in a letter to Martin Fabiani, 20 March 1943, quoted in Duthuit (1988), p.438. See also 'Montherlant: Listening to Matisse', in Flam (1984), pp.78–79.

8 Matisse, in a letter to Marguerite Duthuit, April 1942, in Duthuit (1988), p.437. For Matisse's models see Lydia Delectorskaya, *Henri Matisse: Contre vents et marées: Peintre et livres illustrés de 1939 à 1943*, Paris: Editions Irus et Vincent Hansma, 1996. See also Isabelle Monod-Fontaine, Anne Baldassari and Claude Laugier, *Oeuvres de Henri Matisse*, Paris; Centre Georges Pompidou: Collections du Musée national d'art moderne, 1989; John Elderfield, 'Part VI: 1930–1943: Themes and variations', in *Henri Matisse: A retrospective*, New York: Museum of Modern Art, 1992, pp.357–411.

9 Matisse, in Flam (1984), p.111.

10 John-Antoine Nau, quoted in Duthuit (1988), p.456. Matisse was to travel to Martinique on a 19-day voyage from Tahiti to Panama in July 1930, see *Matisse et Tériade*, exhibition catalogue, Florence: Artificio Edizioni S.r.l., 1996, p.28. See also Philip Larson, 'The exotic ladies of Henri Matisse — Late 1920, early 1930s', *PCN*, 14, 1983, pp.77–81; *Matisse et l'Océanie: Le voyage à Tahiti*, Le Cateau Cambrésis: Musée Matisse, 1988, whence bibliography.

11 Matisse, in Flam (1984), p.109.

*Aimai-je un rêve?*
*Mon doute, amas de nuit ancienne, s'achève*
*En maint rameau subtil, qui, demeuré les vrais*
*Bois mêmes, prouve, hélas! que bien seul je m'offrais*
*Pour triomphe la faute idéale de roses …*
*Réfléchissons …* (Poésies, pp.75–76)

Was it a dream I loved?
My doubt, a heap of ancient night, is finishing
in many a subtle branch, which, left the true
wood itself, proves, alas! that all alone I gave
myself for triumph the ideal sin of roses …
Let me reflect …

(*Stéphane Mallarmé: Poems*, translated by Roger Fry, London: Vision Press, 1951, pp.80–81)

pp.13–19, illustrations from *Poésies* [*Poetry*] by Stéphane Mallarmé
(Lausanne: Albert Skira & cie, 1932)
etching, letterpress on *japon impériale*, with an additional suite
with remarks on *chine*, 33.2 x 25.0 cm (page)
impression 23/30 of the *de-luxe* edition  (Duthuit 1988, 5)

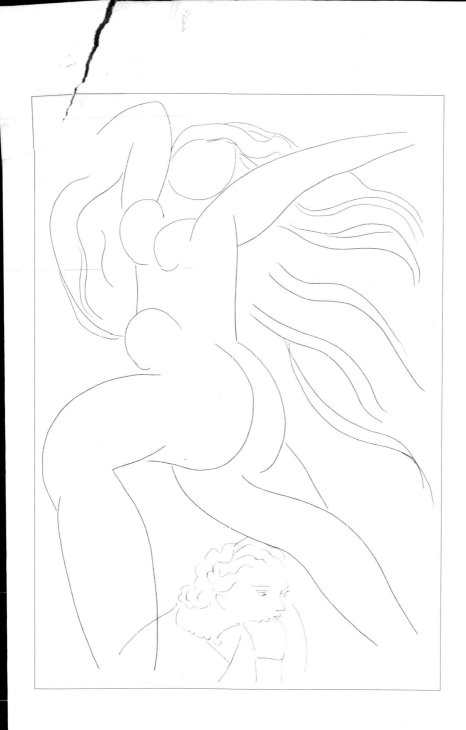

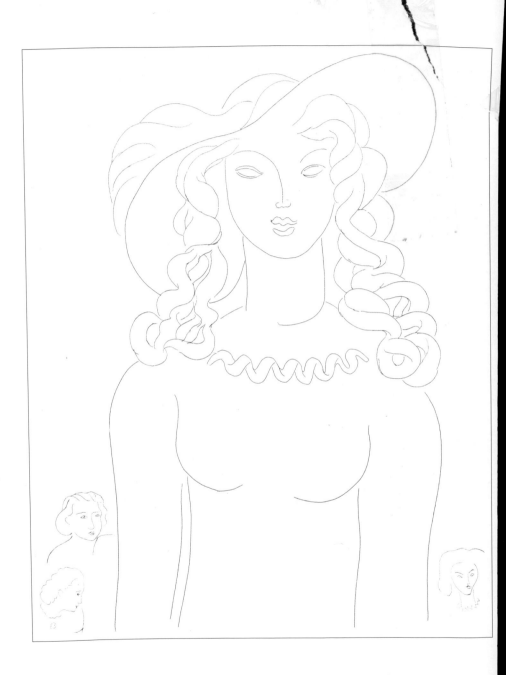

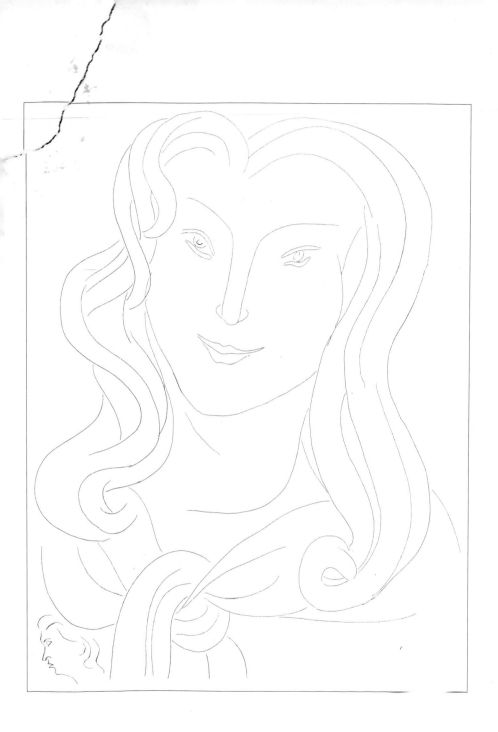

15

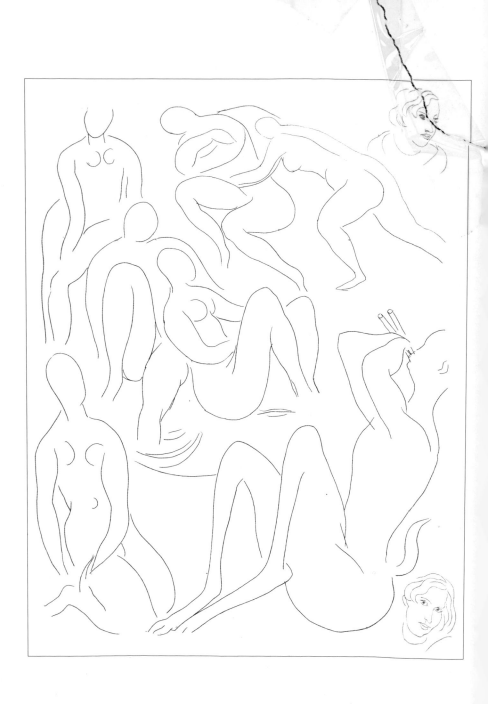

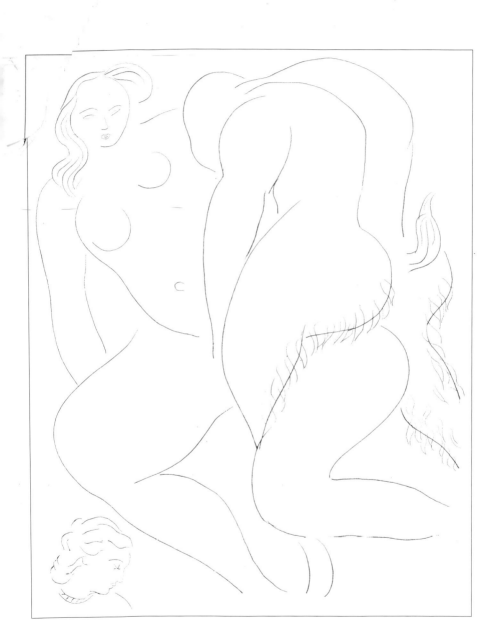

17

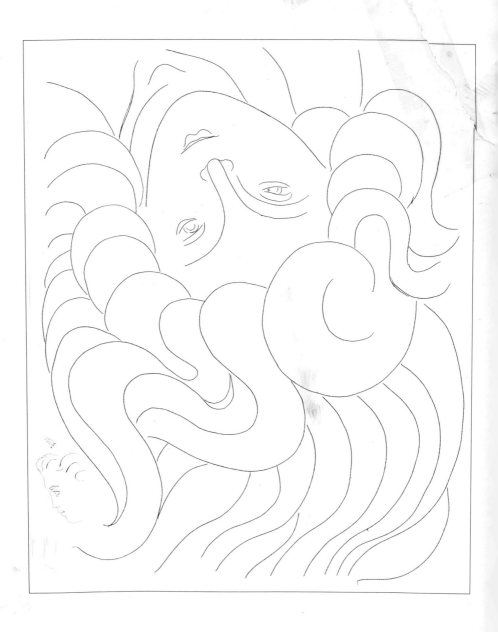

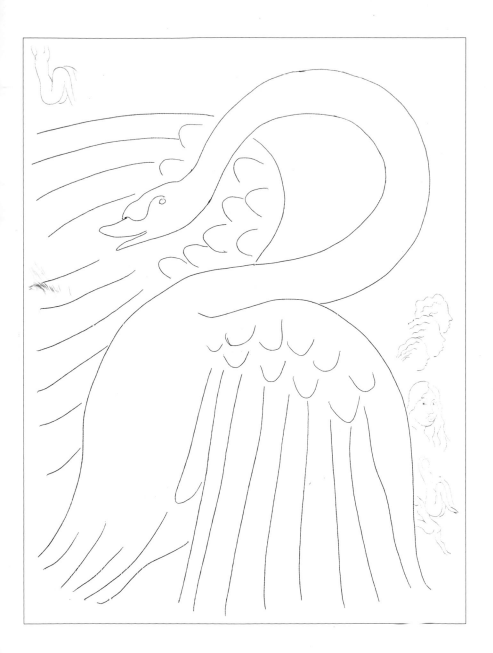

All dimpled cheeks and curls,
Your head it simply swirls ...
Those girls, those girls,
Those lovely seaside girls.

(*Ulysses*, p.31)

pp.21–23, illustrations from *Ulysses* by James Joyce with an introduction by Stuart Gilbert
(New York: The Limited Editions Club, 1935)
soft-ground etching, letterpress on wove paper, 29.8 cm x 23.0 cm (page)
impression 1125/1500   (Duthuit 1988, 6)

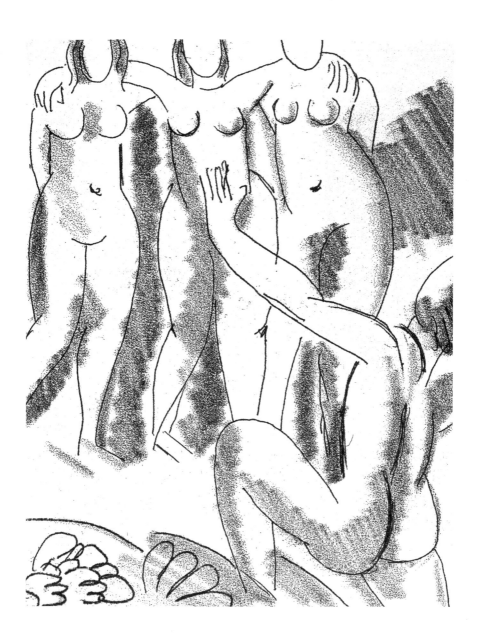

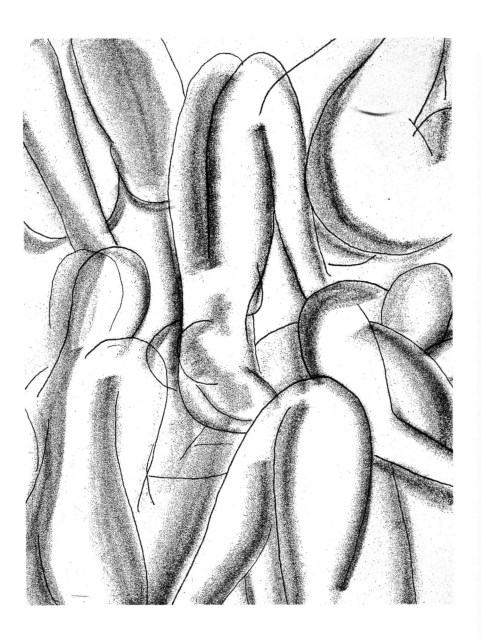

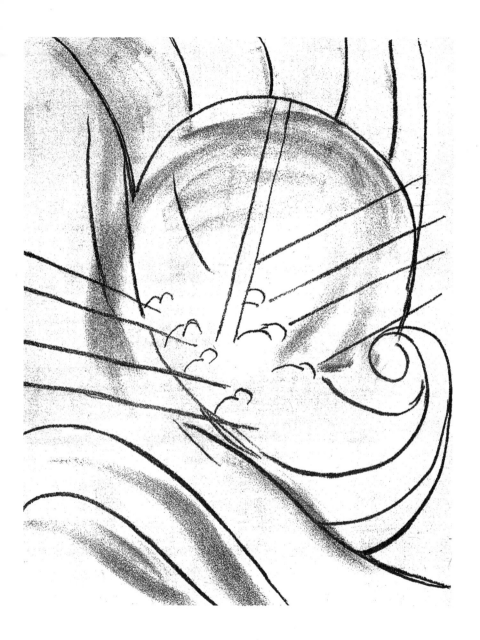

*Et au milieu de tout cela, seul mouvement dans l'étendue qu'il traverse*
*de part en part avec les graces d'un esprit de l'air,*
*un oiseau blanc, délice de la journée.*  (*Pasiphaé, Chant de Minos*, p.57)

And out there, a single movement traversing that motionless
expanse: a white bird, as graceful as a spirit of the air,
a delight of the daylight.

(translation by Patrice Riboust, National Gallery of Australia, 1999)

pp.25–31, illustrations from *Pasiphaé, Chant de Minos (Les Crétois)*
[*Song of Minos (The Cretans)*] by Henri de Montherlant
(Paris: Martin Fabiani éditeur, 1944)
colour linocut, letterpress on *japon ancien,* with a frontispiece pulled on *chine*
and an additional suite of 12 plates on *chine,*  33.7 x 26.2 cm (page)
impression 20/30 of *de-luxe* edition   (Duthuit 1988, 10)
pp.32–33, two variant proof impressions in an edition of 100 from *Pasiphaé* 1944, printed 1981,
linocuts on *BFK vélin de Rive,* maximum 26.6 x 20.0 cm (comp), 32.2 x 25.2 cm (sheet)
(Duthuit 1988, 38 ii)

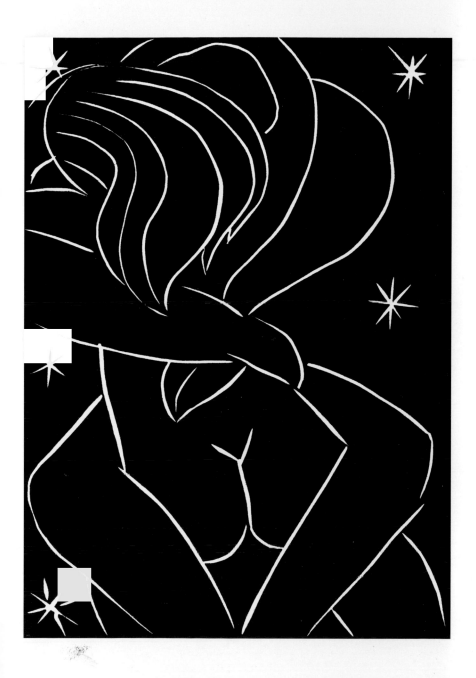

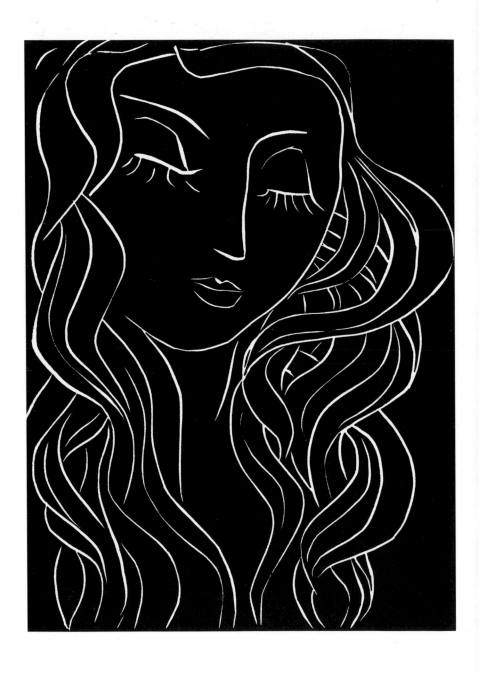

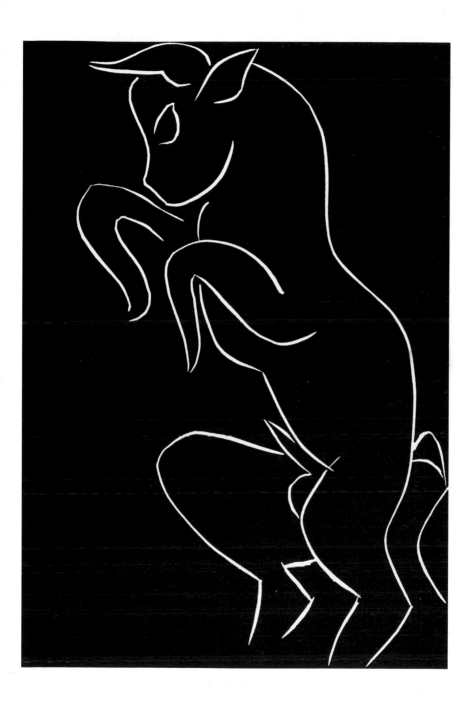

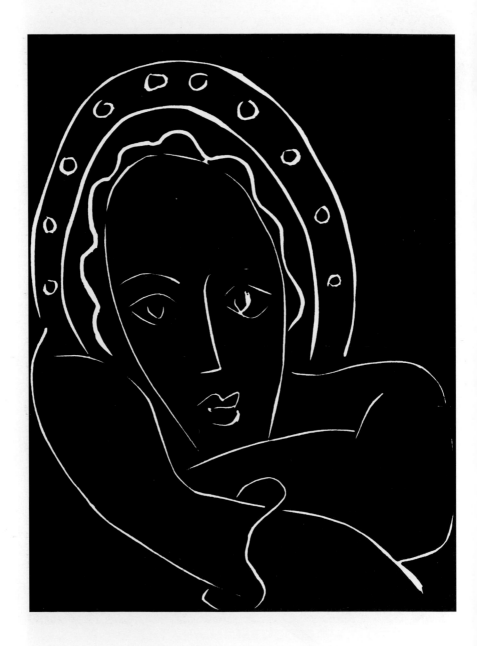

28

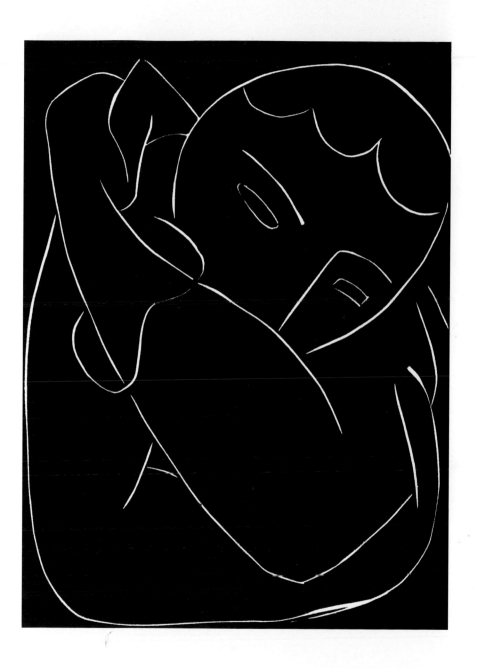

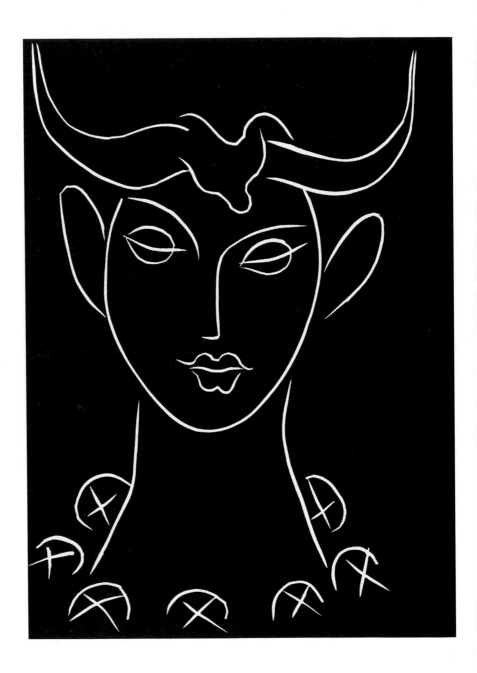

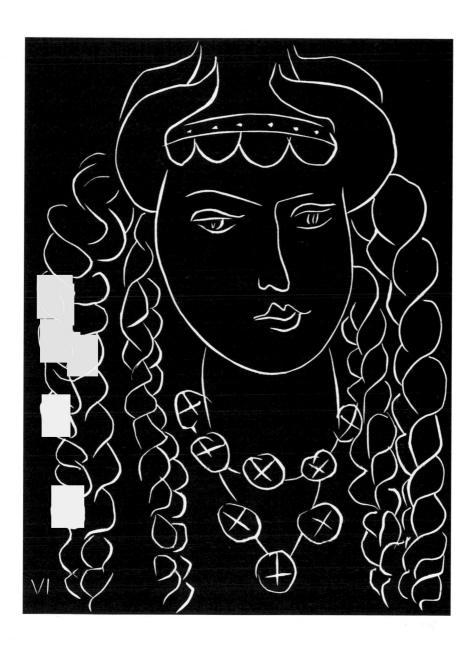

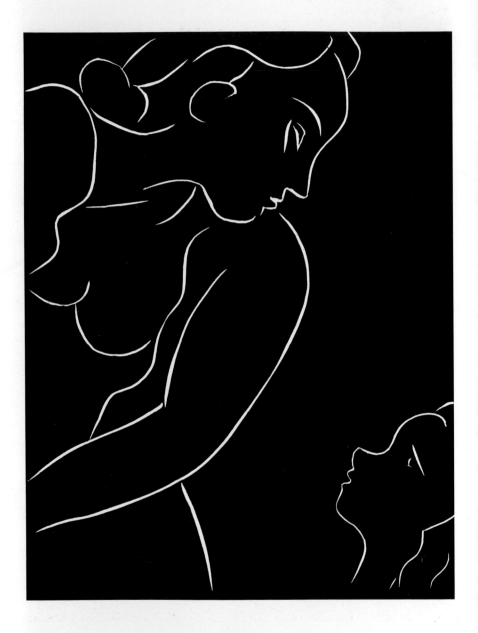

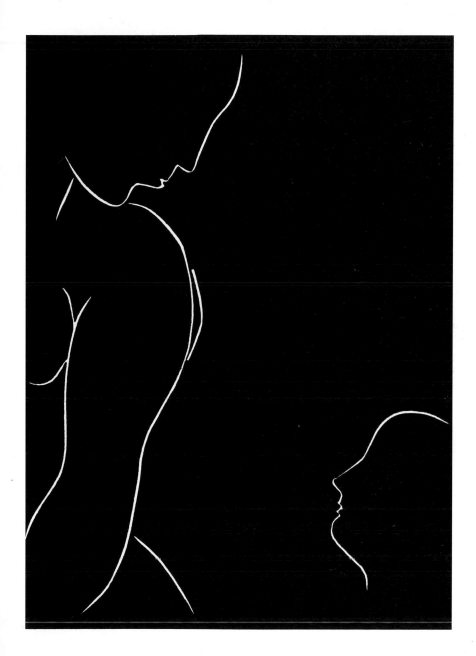

[Gertrude Stein] called me: 'This charmer who takes pleasure in charming monsters.' I never thought of my creations as charmed or charming monsters. I replied to someone who said I didn't see women as I represented them: 'If I met such women in the street, I should run away in terror.' Above all, I do not create a woman, *I make a picture.*

(Henri Matisse: translated by Jack Flam, in *Matisse on Art*, Oxford: Phaidon, 1984, p.82)

*Themes and Variations (Annelies)* 1946
pp.35–37, three pencil drawings from a series on *vélin d'Arches*
52.8 cm x 40.6 cm (sheet)

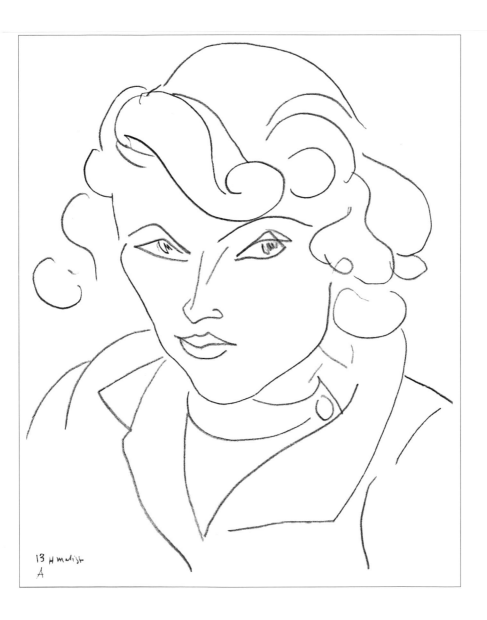

13 H matist
A

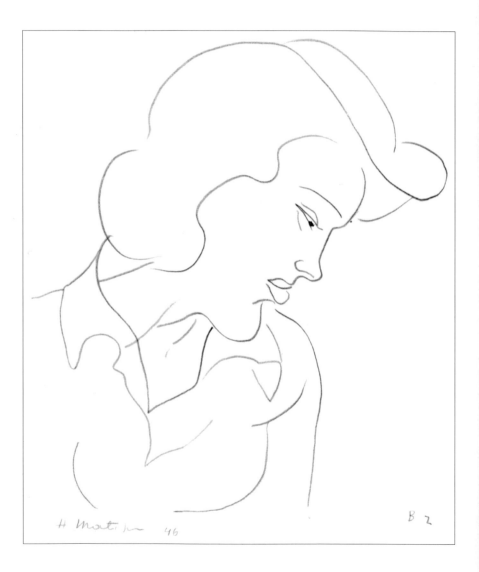

H Matisse 46                                    B 2

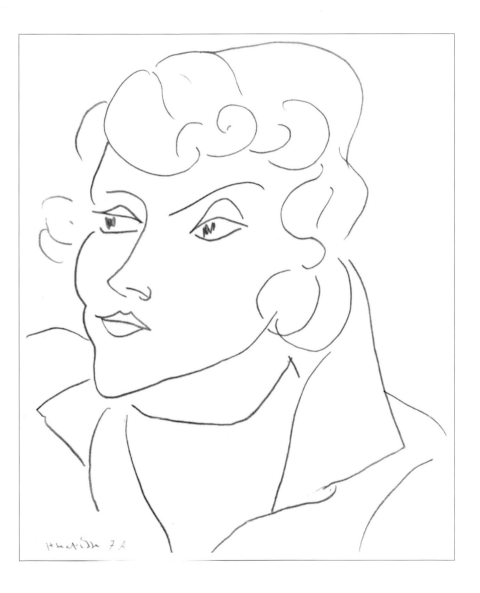

*Je vous escris pour la dernière fois, et j'espère vous faire connoistre*
*par la différence des termes, et de la manière de cette lettre,*
*que vous m'avez enfin …*
*même que je me flattois de n'estre plus attachée à vous …*
(*Lettres portugaises*, pp.87, 91)

I am writing to you for the last time, and I hope to make you
understand from the difference in my expression and the style
of this letter, that even to the last you possess me …
even though I flatter myself that I no longer care for you …

pp.39–43, illustrations from *Lettres portugaises* [*Portuguese Letters*] by Marianna Alcaforado
(Paris: Tériade éditeur, 1946)
colour lithography, letterpress on *vélin d'Arches,* 28.8 cm x 22.2 cm (page)
impression 143/250   (Duthuit 1988, 15)
Gift of Orde Poynton Esq. CMG, 1997

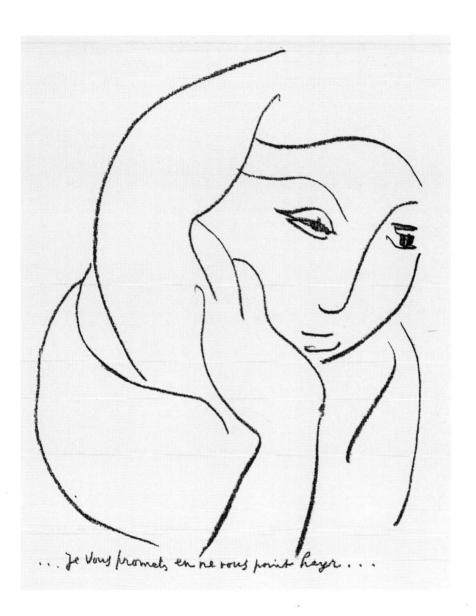

... Je Vous promets en ne vous point hayr ...

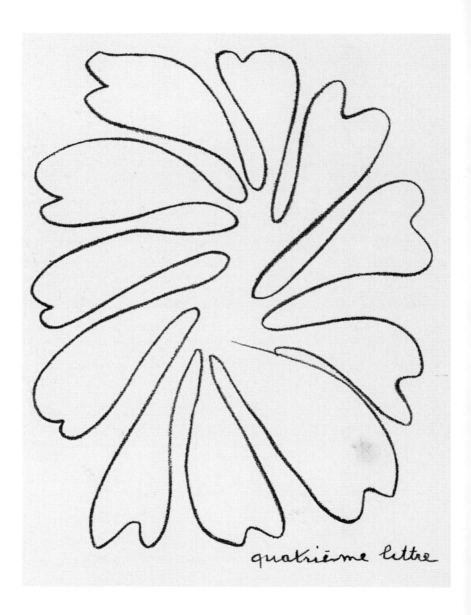

*quatrième lettre*

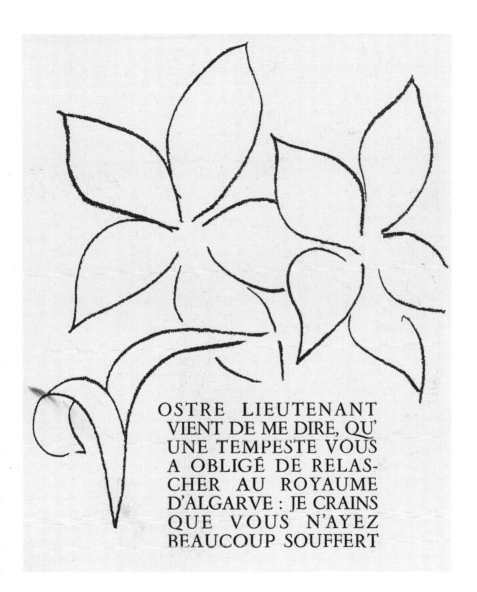

OSTRE LIEUTENANT
VIENT DE ME DIRE, QU'
UNE TEMPESTE VOUS
A OBLIGÉ DE RELAS-
CHER AU ROYAUME
D'ALGARVE : JE CRAINS
QUE VOUS N'AYEZ
BEAUCOUP SOUFFERT

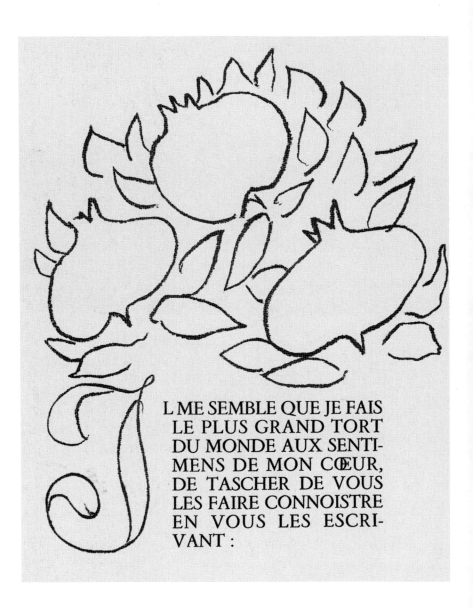

L ME SEMBLE QUE JE FAIS
LE PLUS GRAND TORT
DU MONDE AUX SENTI-
MENS DE MON CŒUR,
DE TASCHER DE VOUS
LES FAIRE CONNOISTRE
EN VOUS LES ESCRI-
VANT :

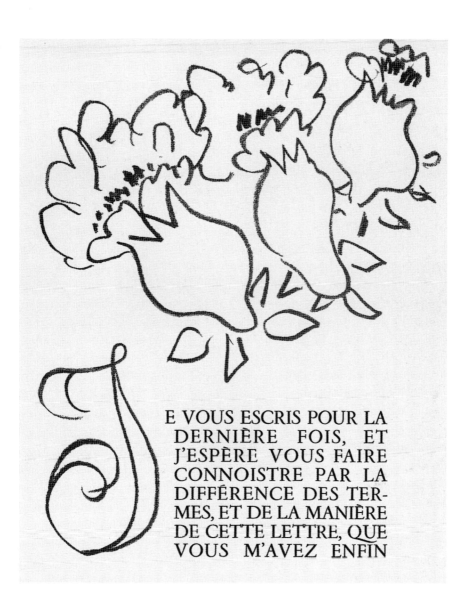

E VOUS ESCRIS POUR LA
DERNIÈRE FOIS, ET
J'ESPÈRE VOUS FAIRE
CONNOISTRE PAR LA
DIFFÉRENCE DES TER-
MES, ET DE LA MANIÈRE
DE CETTE LETTRE, QUE
VOUS M'AVEZ ENFIN

*Lagons,*
*ne seriez-vous*
*pas une des*
*sept merveilles*
*du Paradis*
*des peintres?*
(*Jazz*, p.128)

*Lagoons:*
wouldn't you be
one of the
seven wonders
of the Paradise
of painters?

(Henri Matisse: translated by Jack Flam, in *Matisse on Art*, Oxford: Phaidon, 1984, p.113)

pp.45–49, illustrations from *Jazz* by Henri Matisse  (Paris: Tériade éditeur, 1947)
colour stencil, lithography on *vélin d'Arches*, 42.2 cm x 32.8 cm (page)
impression 39/250   (Duthuit 1988, 22)

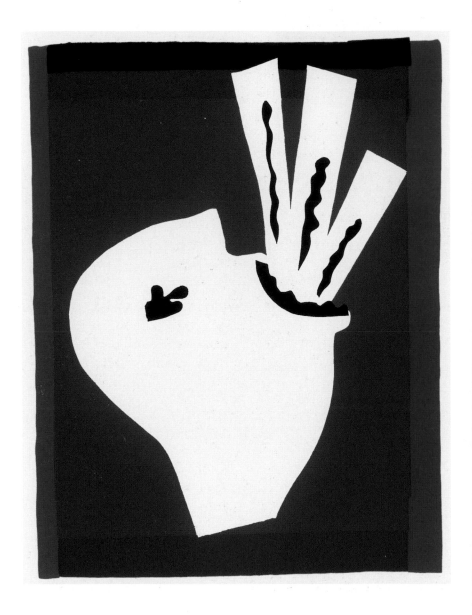

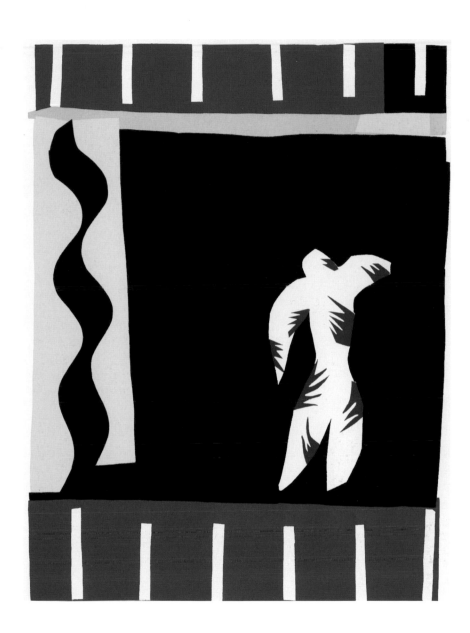

*Je vous envoye un bouquet que ma main*
*Vient de trier de ces fleurs épanies,*
*Qui ne eust a ce vespre cuillies,*
*Cheutes à terre elles fussent demain.*

(*Florilège des amours de Ronsard,* p.127)

I am sending you a bouquet of flowers in full bloom
Just gathered by my own hand,
Had they not been picked this evening,
By tomorrow they would have fallen to the ground.

pp.51–57, illustrations from *Florilège des amours de Ronsard* [*Anthology of Love by Ronsard*]
by Pierre de Ronsard, selected by Henri Matisse  (Paris: Albert Skira, 1948)
colour lithography, letterpress on *vélin teinté pur chiffon, Arches*
38.5 cm x 29.5 cm (page), impression 157/300  (Duthuit 1988, 25)
Gift of Orde Poynton Esq. CMG  1993

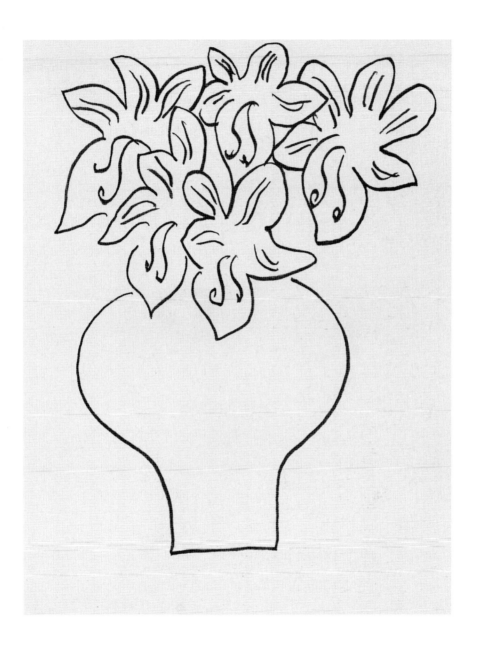

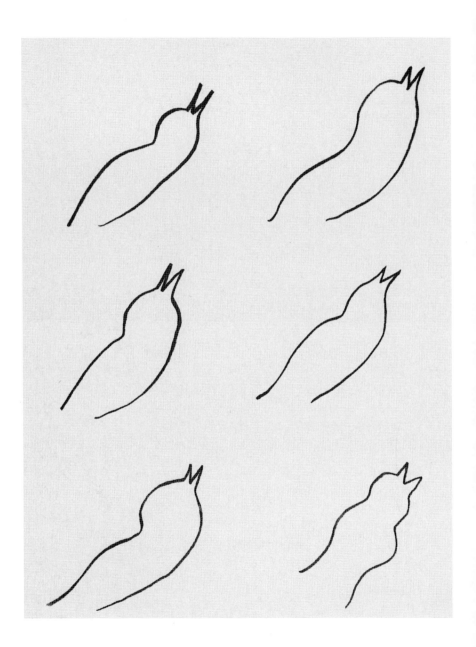

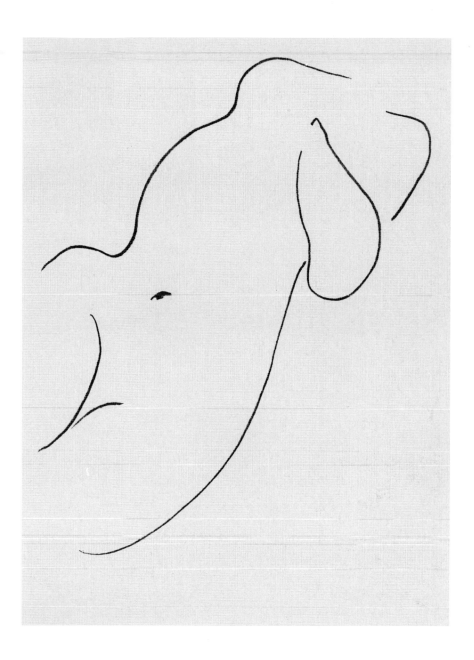

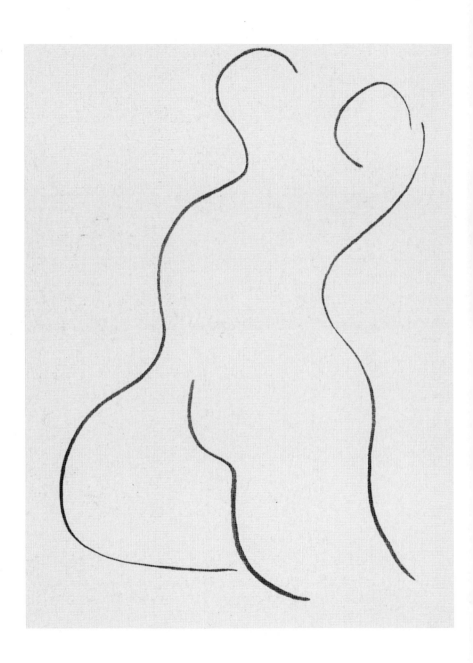

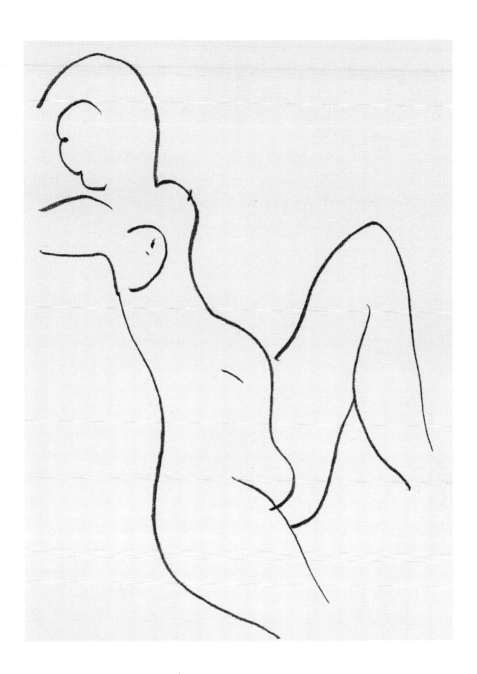

*Belle, bonne, non pareille, plaisant,*
*Je vous suppli, veuilliez me pardonner ...*
(*Poèmes de Charles d'Orléans*, p.22)

Comely, estimable, beyond compare, charming lady,
I implore you, will you please forgive me ...

pp.59–61, illustrations from *Poèmes de Charles d'Orléans.*
*Manuscrits et illustrés par Henri Matisse*
[*Poems of Charles d'Orléans. Manuscripts and illustrations by Henri Matisse*]
(Paris: Tériade éditeur, 1950)
colour lithography on *vélin d'Arches*, 40.8 cm x 26.4 cm (page)
impression 867/1200 (Duthuit 1988, 28)
Gift of Orde Poynton Esq. CMG 1993

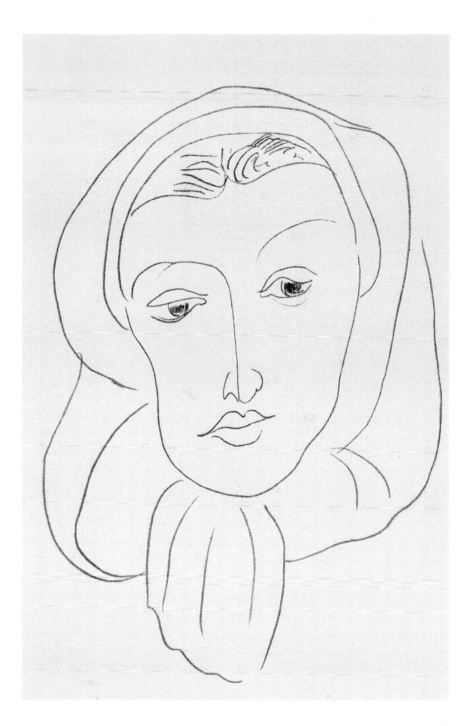

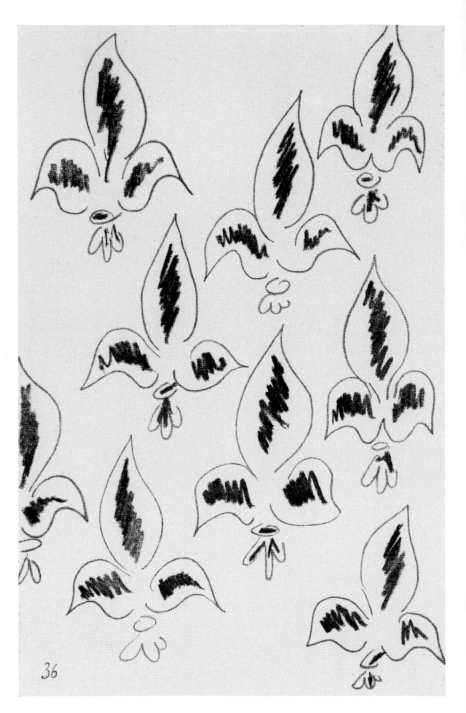

36

*Ainsi je vois ton amitié*
*Fleurir comme une belle rose*
*Je ne t'aime pas à moitié*
*Bientôt te l'écrirai en prose.*

(*Apollinaire,* p.48)

Thus I see your friendship
Blossom like a beautiful rose
My love for you is not half-hearted
Soon I shall tell you in prose.

pp.63–65, illustrations from *Apollinaire* by André Rouveyre (Paris: Raison d'être, 1952)
colour lithography, aquatint, letterpress on *vélin d'Arches*
with an additional suite of one aquatint and nine colour lithographs
33.6 cm x 26.0 cm (page), impression 10/30 of the *de-luxe* edition   (Duthuit 1988, 31)
Gift of Orde Poynton Esq. CMG 1993

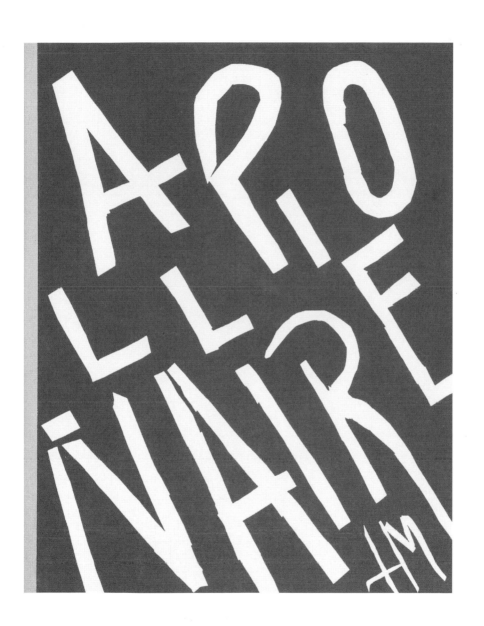

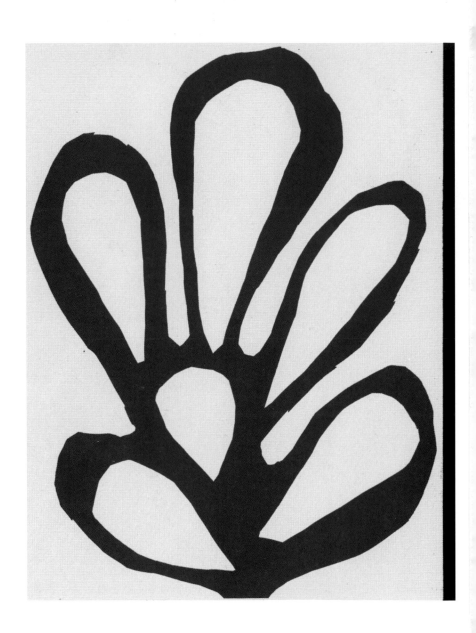

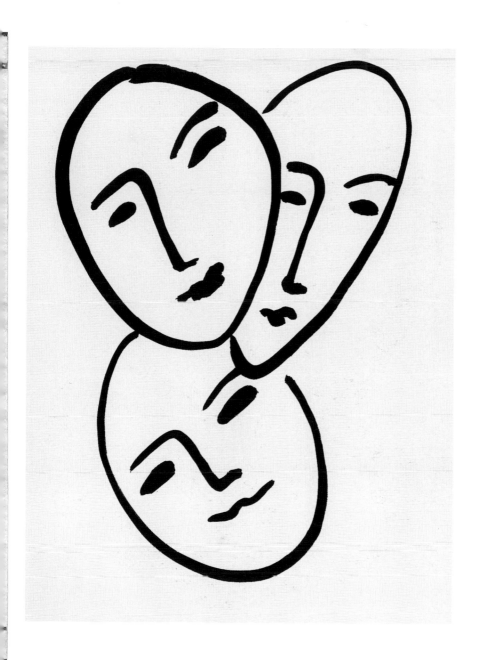

*Sur l'arc vert de la plage apaisée*
*Où le matin mélodieux descend,*
*Ta maison pâle*
*entre les palmes balancées*
*Est un sourire las*
*sous un viole flottant.*

(*Poésies antillaises*, p.61)

On the green arc of the tranquil beach
Where melodious morning is breaking,
Your pale coloured house
between swaying palms
Is like a tired smile
beneath a floating veil.

pp.67–71, illustrations from *Poésies antillaises* [*Antilles Poetry*] by John-Antoine Nau (Paris: Fernand Mourlot, 1972, printed from maquette by Henri Matisse 1950–53) colour lithography, letterpress on *vélin d'Arches* with a watermark, a woman's head in profile, after a drawing by the artist, 38.4 x 29.4 cm (page), impression 143/250 plus a *de-luxe* suite of 12 supplementary original lithographs on *japon*
(Duthuit 1988, 37)

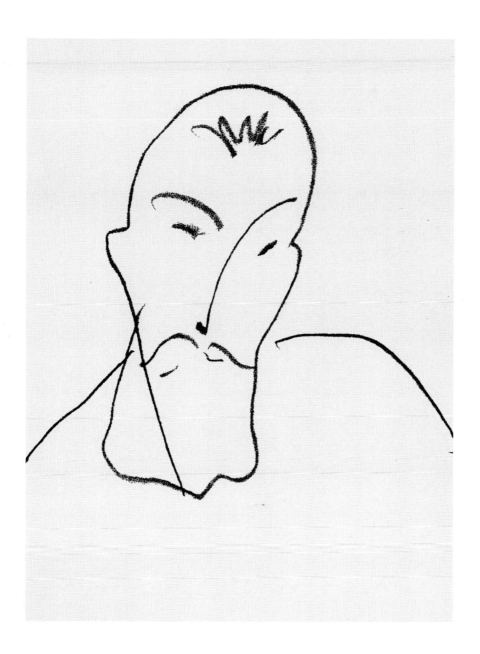

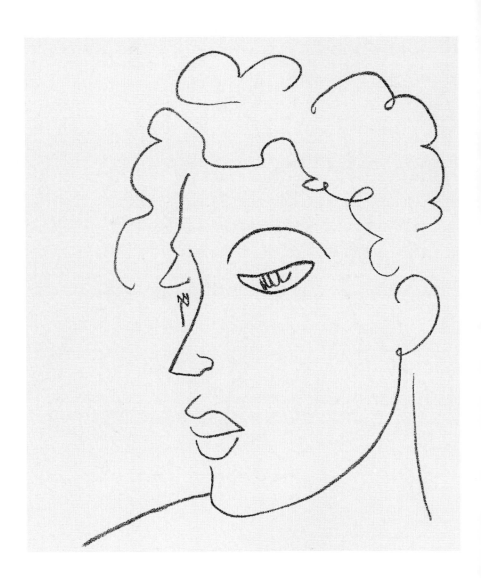

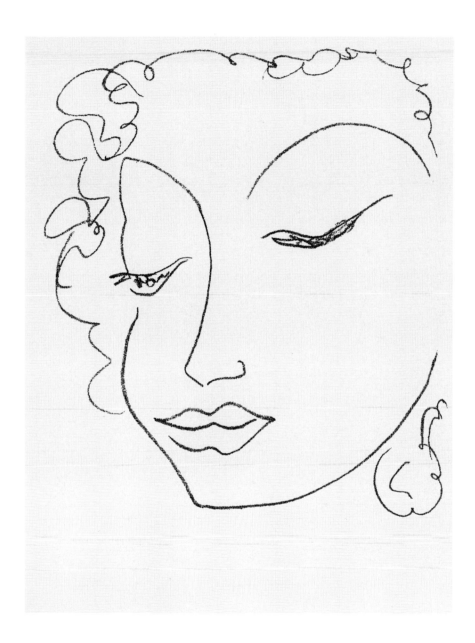

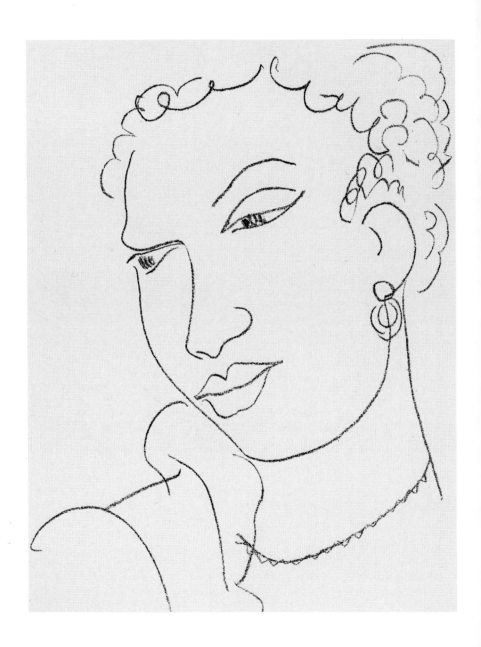

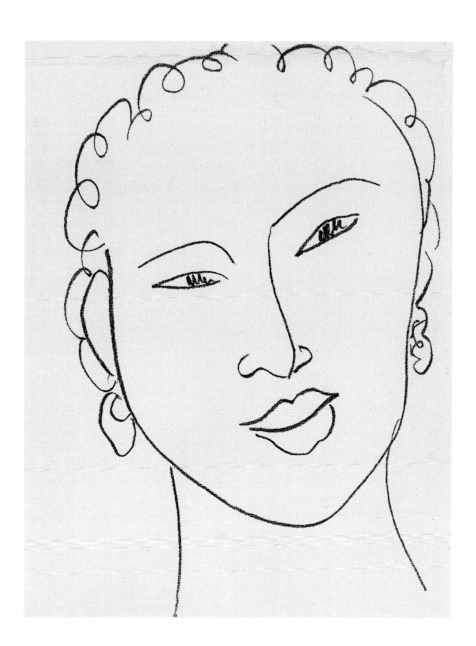

*Introduction and Catalogue*
Jane Kinsman
Senior Curator, International Prints,
Drawings and Illustrated Books
National Gallery of Australia

The French texts included in the catalogue
are from the Matisse illustrated books cited,
and page references are given.
Works reproduced are from the standard
editions unless otherwise stated.
Measurements are given in centimetres,
height before width.
Claude Duthuit, *Henri Matisse: Catalogue
raisonné des ouvrages illustrés*, Paris:
Claude Duthuit, 1988, referred to throughout
the catalogue as (Duthuit 1988).

All works are in the collection of the
National Gallery of Australia.
©1999-Succession H. Matisse. Reproduced by
permission of VISCOPY Ltd, Sydney 1999

(cover)
From *Pasiphaé, Chant de Minos (Les Crétois)*
[*Song of Minos (The Cretans)*]
by Henri de Montherlant
(Paris: Martin Fabiani éditeur, 1944)

(title page)
From *Florilège des amours de Ronsard*
[*Anthology of Love by Ronsard*]
by Pierre Ronsard, selected by Henri Matisse
(Paris: Albert Skira, 1948)

(page 3)
*Blouse romaine* [*Roumanian blouse*] 1938
charcoal drawing on Maillol laid paper*
60.6 cm x 40.8 cm (sheet)
(*Nude and ribbon watermark designed by
Aristide Maillol for the papers produced by his
nephew Gaspard Maillol at their mill at Montval,
Peter Bower, Paper historian, 1999.)

Designed by Kirsty Morrison
Edited by Pauline Green
Printed by Goanna Print, Canberra

Cataloguing-in-Publication data

Matisse. Henri. 1869–1954
Intimate Matisse.

ISBN 0 642 54122 1.
1. Matisse. Henri, 1869–1954 – Catalogs.
2. National Gallery of Australia – Catalogs.
I. Kinsman, Jane. II. National Gallery of
Australia. III. Title
741.944

*Distributed by Thames and Hudson:*
11 Central Boulevard, Portside Business Park,
Port Melbourne, Victoria 3207, Australia

30–34 Bloomsbury Street,
London WC1B 3QP, United Kingdom